T0148322

WATCHING
FROM THE SHADOWS

Through eyes of passion, 24 biblical women tell their stories

Edna M. Gallington

Elizabeth Bird Norton, Artist

WestBow
PRESS

Cover Design by Jonathan Reed, graphic designer, for Billy Graham Evangelistic Association and for Wildfire Ideas

Interior Design by Stefanie Holzbacher

WestBow Press books may be ordered through booksellers or by contacting:

WestBow Press
A Division of Thomas Nelson
1663 Liberty Drive
Bloomington, IN 47403
www.westbowpress.com
1 (866) 928-1240

ISBN: 978-1-4497-0254-0 (sc)
ISBN: 978-1-4497-0255-7 (dj)
ISBN: 978-1-4497-0253-3 (e)

Library of Congress Control Number: 2010929963

Printed in the United States of America

WestBow Press rev. date: 7/19/2010

As you read the stories in this book, curl up in a favorite chair and, for a moment, let your eyes drift over the portrait of a woman with deeply expressive eyes, eyes that harbor sadness, innocence, or joy. Listen to her tell her story. Feel the drama, the excitement, and the mystery. Remember along with her as she pensively shares her story—if she could have penned it—perhaps in her journal. She is a woman not much different from you, an ordinary woman suspended in an extraordinary moment of time, one that changed her life forever.

This book is dedicated to the memory of my mother, who longed to be a writer.

CONTENTS

Acknowledgements. .xi

Introduction. .xiii

On a Rainy Friday Evening . 1

Bathsheba, the Desired. 5

Lot's Wife, the Lingering One . 9

Leah, the Rejected . 13

Rachel, the Betrayed. 17

Rahab, the Curious . 21

Hannah, the Longing Mother 25

Ruth, the Beloved Poet. 29

Temple Girl, God's Own . 33

Delilah, the Betrayer. 37

Deborah, the Brave and Strong 41

Abigail, the Gracious Woman. 45

Esther, the Beautiful Queen . 49

The Prodigal Daughter. 53

Gomer, the Reluctant Wife . 57

Anna, a Woman after God's Own Heart. 61

Woman at the Well, the Seeker. 65

Glimpse of a Stranger, the Forgiven 69

Forgotten Woman, a Touch of Faith. 73

Jairus' Daughter, a Miracle. 77

Mary, the Listener . 81

Martha, the Organizer . 85

Pilate's Wife, the Silent Observer . 89

Mary, the Mother of Jesus . 93

Mary, the Adoring One . 97

The Author. 99

The Artist. 101

Acknowledgements

Many people helped me bring this book together. I deeply appreciate each of you for your encouragement and patience, and for the tireless hours you spent working with me. You are truly my friends.

Linn Norton McClellan, adopted daughter of the artist

Reuel A. Minton, business partner/art portraits

Jonathan Reed, cover design, graphic designer for Billy Graham Evangelistic Association and for Wildfire Ideas

Sylvia Clark, creative editing and insights

Jocelyn Fay, editorial review/copy editing

Janet French, creative editing/promotion ideas

Joanne Nightingale-Andrus, Nelma Fennimore, Vera May Schwarz, and Sarah Walsh, friends who provided fun and insights

Toini Harrison, my college professor

Roberta Moore, a college professor who taught me how to write and asked, "Do you realize how special you are?"

Ellen Morse, copy editing

Judi Nelson, creative editorial comments

Kit Watts, who through the years honed my many articles

Tama Joy Westman, my writing mentor

Halcyon Wilson, my pastor, who gave me much encouragement

Florence Littauer, who offered me learning experiences in CLASSeminars

Wallace, my husband, whose love and emotional support I treasure

And to God, who kept His promise.

Introduction

No legacy gives a picture of how biblical women felt about their experiences—others wrote their stories. They kept them in their hearts, to relive again and again the emotions they felt.

But what if we could have found their journal, or even a note here and there? How would they have recorded those special moments that gained for them a place in biblical history—their encounter with God?

These stories were not easy to write. Rather than taking a historical viewpoint, I wrote from an artist's viewpoint: part fact, part imagination. I tried to put myself in each woman's place, experience her joy and feel her pain. Tears often blurred the pages as I wrote—tears of hurt for Mary, the mother of Jesus, at the cross. Tears of joy stung my eyes as Mary heard Jesus call her name after the resurrection. No words can fully describe these experiences.

I am in awe of the beautiful sketches of the biblical women the artist so lovingly portrayed. Many of the women's eyes harbor sadness, but they believed in a God who makes things right, One who, as the Old Testament prophet Joel says, "restores what the locusts have eaten." This God is "Watching From the Shadows" of our lives to eventually bless us, and that is what God's love and grace is all about.

Writing their stories, seeing their lives through their eyes, has brought me closer to God, who loved each one of these women

with the same love he has for you and me. One thought stands out: many of the stories have happy endings—Jesus' resurrection, the birth of a desired child, a rescue in spite of impossible odds, or a homecoming at last.

Jesus honored women. He revealed himself the first recorded time as the Messiah to the woman at the well. The first person to see and greet him after his resurrection was a woman. It is as if he is telling womankind, you are accepted, forgiven, redeemed, and deeply loved. The Messiah came through the lineage of several of these women—Bathsheba, Rahab, and Ruth.

My hope is that you too will share my inspiration and joy as you linger to observe the women's expressive eyes, look into their hearts, and imagine how they might have scripted their stories.

—Edna M. Gallington, author

On a Rainy Friday Evening

This book came together on a rainy Friday evening as I lingered at an exhibit of 24 paintings of biblical women on display near my hometown. I paused beside each picture, captivated by the emotions revealed in the artistic eyes of the women, eyes that spoke directly to my heart. As I stood there, I wished the artwork could be placed in a book that I could take home to treasure and to enjoy again and again.

Aware of someone beside me, I turned to see a friend, who also was observing the artwork.

"These pictures are awesome!" I exclaimed.

"I own them," he replied. I felt my breath catch.

"Have you thought of putting them in a book so more women can view them?" I questioned, feeling the excitement of the moment.

I waited, trying not to appear too eager—even though I was. After thinking a moment, he acknowledged that it just might be a good idea.

"May I write the stories?" I blurted out. It was all very much on the spur of the moment. That night I went home to write the story of Bathsheba and e-mailed it to him. Thus began a partnership to bring this book to you.

But the story doesn't begin here. Even in my teens, I enjoyed putting myself in the sandals of Bible characters, especially women, and writing their stories. Through the years, many of my devotional

stories were published, but I kept the first-person women's stories in a folder, for my eyes only. One exception was "Glimpse of a Stranger," which was published in a youth magazine when I was in college.

The story of the artwork goes back more than 25 years to when Elizabeth Bird Norton finished the last of the 24 portraits just before her death. She desired to display her artwork and tell the women's stories.

Elizabeth did not live to see that dream fulfilled. The portraits languished in the garage of her adopted daughter Linn's home, while Linn searched for the father she never knew.

One evening my friend, the owner of the artwork, received an e-mail. Linn had found her father and he had found his daughter. Later, Linn expressed the desire to give her father the artwork of her adopted mother in hopes he could display it.

The dream of four people merged that rainy Friday evening to bring you this book: an artist who wanted to share her paintings with all women, a daughter who gifted the pictures, an author who as a teenager loved to write women's stories, and a friend who helped bring it all together.

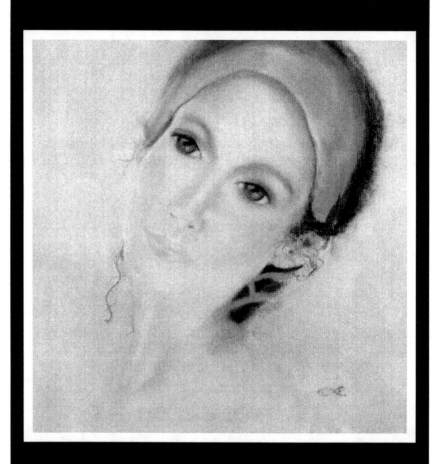

Bathsheba, the Desired

Bathsheba, the Desired

The silky evening bathed my skin in moonlight. Warm water swathed over my body, relaxing every muscle.

My hideaway, where I could be alone to think, to meditate, or just be. I came here for my bath, but sometimes I just sat and watched the sun rise or set over the city. As always, alone in my garden, I loved my hideaway. I did not know that one moonlit evening would leave me with sadness forever.

As I bathed, I thought I was alone—but I wasn't. I hadn't been for some time. I didn't realize it, until a messenger summoned me to the king's palace.

Of course I had to go. You don't refuse a visit to the king!

We feasted in luxury, course after course of delicious food: grapes, pomegranates, figs, cheese, and breads. The king was a magnificent, attentive host.

He told me that my exquisite beauty shone through my eyes, my form, and my movement—that I was more beautiful than any woman he had ever seen. He told me that he had been a watcher as I bathed. I don't remember much of what happened that night, only that he held me in his arms, made love to me in his chamber, and sent me home in the predawn darkness.

My spirit deeply troubled, I could not speak of this to anyone. My servants asked what was wrong, but I couldn't tell them.

I missed going there, my precious hideaway, the place to think and pray, but I could no longer pray.

Guilt! It didn't leave me. I loved my husband, away at war in the king's service. He was incredibly devoted, but I had betrayed him. He loved me so.

Then I made a discovery that chilled my heart. I was with child. I quickly sent a message to the king. That week my husband arrived home on leave. My heart overflowed with delight. We loved making our home together and planned a wonderful family of sons and daughters. I had looked forward to the night when I could snuggle in his arms and hear his voice. That night my husband told me he could not immerse himself in my love while his friends fought on the battlefield. This husband of mine, so dedicated to God and the king, slept by the door and the next day returned to battle.

When I received news that he had been killed, speared to death on duty at the front line, my heart broke. A dark cloud settled over my life. I could never get on the other side of my deep grief. No one knew how desperate I felt, and I could not share my feelings with anyone.

When my days of mourning ceased, according to our tradition, but not according to my heart, the king sent for me.

I didn't want to go, but I had to. You don't refuse a king. He wanted me for his wife—not because he loved me, but because he desired me.

Oh, how I wish I had not been born beautiful, but born just an ordinary girl, who could have lived contentedly with my husband and children. Oh, how I miss my husband.

I should be happy. I am the queen living in a palace of splendor, wearing rich garments, with maidservants attending to my every need. And—I am carrying the king's child.

But in my heart traces of guilt remain. I long for peace with God. And the sadness never goes away. (2 Samuel 11, 12)

Note: Although cast into circumstances she couldn't control, Bathsheba was tremendously blessed by God. Even though her first son died at birth, her second son was Solomon.

Along with his father, King David, he became one of the greatest kings of Israel, no doubt due in part to the tender care and training of his mother. Bathsheba became a strong, influential, and beloved queen and was instrumental in placing her son Solomon on the throne after King David's death. At Solomon's wedding she had fashioned a crown of gold for his head. Solomon also mentions his mother as one who tenderly loved him as a mother loves her only child. Through her line, the Messiah was born.

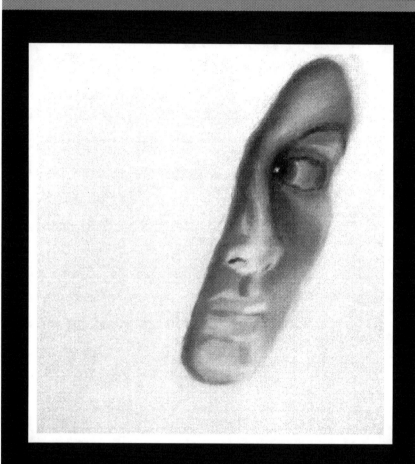

Lot's Wife, the Lingering One

Lot's Wife, the Lingering One

My Dearest Husband,

I feel hurt, betrayed! Anger and grief overwhelm me. I have talked to you, my husband, cried, begged, tried to reason with you. You will no longer listen! You will no longer even talk with me!

I am writing you carefully on this thin papyrus with a black stone. I will hand it to you when we leave. Perhaps then you will understand! Tomorrow morning we leave our beautiful home in the city of the plains—just walk out taking only a bag of our most treasured possessions. I wouldn't go, except our daughters are going with you, their father, and I cannot have them go without me.

Just walk off? Leave my home, windows looking out across the plains, relaxing desert sunsets? My home that you, my husband, provided for me? Pottery from afar adorns the walls. Exquisitely woven mats cover the floors. Gowns with threads of many colors hang in my chamber. All this? And I must leave it for those distant mountains? There's nothing up there except rocks and caves. And snakes! You know how much I hate snakes! We'd have to drink from a stream. I don't know what we would eat. Where would we live?

All because two men came last evening and talked with you long into the night. Now you are unreasonable. You say the men sent by God were angels, or some such messengers. They told you that the city will be destroyed tomorrow. We have to leave.

Wickedness pulses in the veins of our city, I know. At night vice lurks on the corners and gangs tread the streets. We can't go outside. One gets used to it. Yet it is a striking city by daylight, a city of opulence and luxury. Sunbeams bounce off the golden altars, monuments of beauty.

I'm not even sure I believe in your God anymore. When we first came to the cities of the plains, we prayed morning and evening. We worshipped as a family. Then other things began to take my attention—decorating my home, selecting wares the camel merchants brought, gathering at the booths with the women of the city. Time with God just got crowded out for me.

We have so much here, my dear one, our friends, a bounty of figs, pomegranates, lemons, olives. We want for nothing. We are highly respected in the city. *You* are highly respected.

I cannot go. I have wailed all night, as one cries for one's dead. You comforted me at first, but even you turned away from me.

"We have to go," you said, "and we won't discuss it any longer." Even my daughters don't understand.

But before we leave this morning, I write this so you will listen, so you will understand. I will place this letter in your hand just before we walk out the door.

Your last words invite me as I finish this letter, "Walk with me, my love, and don't look back." But, my dear one, I must linger—just for a moment—for one last look. Don't you understand? (Genesis 18, 19:16-29)

Note: Lot and their daughters walked on alone. Some biblical historians suggest that when Lot's wife turned to look back and became a pillar of salt, the term "pillar of salt" was used to describe a massive heart attack or stroke. God in his love and care for Lot's family asked them not to look back to see the flames of Sodom destroy their home. He asked them to walk forward in faith with him.

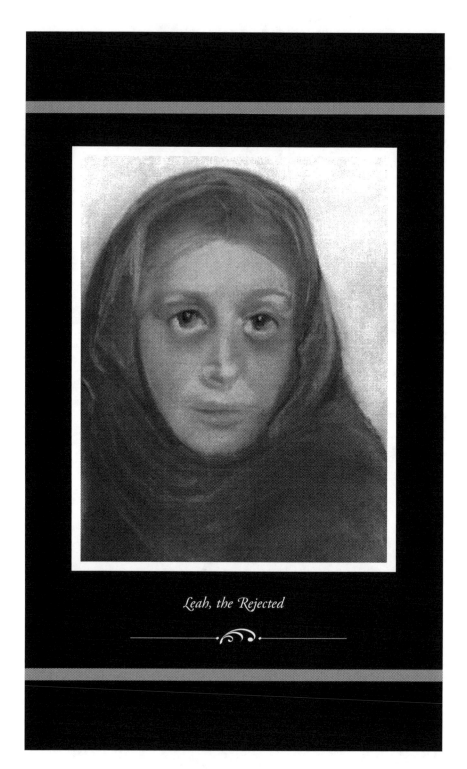

Leah, the Rejected

Leah, the Rejected

My sister will hate me forever! That was my first thought. A mixture of confusion, betrayal, happiness, and sadness cavorted through my mind. It was my sister's wedding night—after a week of festivities and celebration.

Now, all because of me, her joy had vanished. That evening my father told me to prepare myself as a bride. He would present me to Jacob instead of Rachel. Jacob's beloved. I felt hurt, anger, and betrayal—not the eagerness a bride should feel. And a wedge would be driven between my sister and me forever.

"It is our custom," my father said, "to give the older sister first in marriage." Older indeed! He had never told me that before. Ugly, mousy-colored hair; sad, plain eyes; skin darkened from the sun; almost no breasts—and I limped, too. No man would ever want me. I tried to make up for it by working hard around the house. Maybe my father thought he was doing me a favor, but he wasn't. Rejection still dims my self-confidence.

I can't speak of that night—the wedding night. I cry every time I think about it. I will never forget the disappointment on Jacob's face when he lifted the veil to behold his beloved, his delight—and discovered me. And I know my sister must have cried angry, hurt tears on her mat during those dark, lonely hours.

In the morning we walked out of our tent with smiles on our faces and tear streaks on our cheeks, but we had the blessing of our family and community.

Rachel and Jacob were so much in love. She'd take him water jugs as he tended our father's sheep, every moment together precious to them. Jacob worked for seven years to obtain Rachel as his wife.

My sister, the adored one, had been good to me. She protected me somewhat from the buffeting others gave me, but even she taunted me when I annoyed her. From their looks and whispers, the entire family, I sensed, felt sorry for me.

"It will turn out for the best," my father comforted, "wait and see." Best for whom? Not for me! For the rest of my life I would feel Jacob's look. This feeling of being discarded, this inner rejection would impair my relationship with my sister, my father, my husband, and my children forever!

Jacob, as always the gentleman, took me to be his wife. I tried in every way to please him, but I knew in my heart he counted Rachel his darling and only tolerated me. Yet through the years the Lord blessed me with many sons. Sons! You could only know what that meant to a woman if you lived in our culture—what a great honor to her and her husband.

With the birth of each son, I think, *Perhaps now my husband will love me.* I covet his love so much, but he spends most of his hours with her. I keep busy caring for my sons, knowing that God has not forgotten me. Many nights I cry and hope my sons will never know. And yet—yet, I know they feel the difference in our home. (Genesis 29, 30)

Note: Indeed Leah was blessed of God. Jacob's sons became the tribes of Israel. Through the lineage of her son Judah came kings, leaders, and eventually the Messiah. Although the Scriptures don't say, perhaps in time Jacob did come to love Leah. Before he died, he asked to be buried by her side.

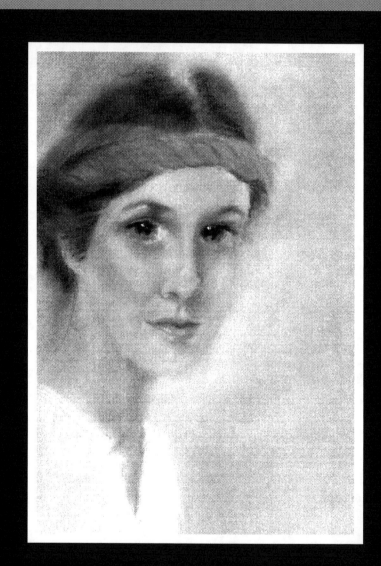

Rachel, the Betrayed

Rachel, the Betrayed

All week long the pampering and glorious wedding festivities focused on me, the cherished, treasured bride-to-be. Now my sister Leah flourished in my marriage bed with my beloved husband-to-be.

My own father betrayed me that night—my wedding night. Not me, but my older sister, Leah, he led to the marriage bed. My own father betrayed us! He said, "It must not be done in our country, to give the younger before the firstborn. The older sister must be given first in marriage." But I knew in my heart that he was sure this was his only chance for Leah to marry—and I drenched my bolster with lonely tears.

I could hardly stand it—the festivities and the wedding night. I kept to myself the entire time he was with her. I longed for his caresses, his tender kisses, the fruit and wine. I should have shared his tent and felt his loving arms around my body.

We had waited seven years to be married, Jacob and I. Our love grew stronger with each passing year. As those years flew by, we longed to be husband and wife—to have a family of adored children.

I know, our father did what he thought best, but I didn't think so—not for me. And I thought I was his favorite. He said not to worry, the other seven years Jacob was bound to work for me would go by quickly. My own father didn't understand my feelings at all—I wanted to be the first and only!

After Jacob's time with Leah, our own wedding night lacked the ambience and the ecstasy. My own emotions were spent from crying. Yet Jacob, kind and loving, made me feel whole again—his darling, beloved woman.

Jacob toiled hard raising sheep for my father and enlarging our flocks, but I knew he too felt betrayed. I knew he loved me best, and that was some comfort.

I will say for Leah, however, that she worked hard and took good care of Jacob and the sons she bore him. In her heart I think she was grateful to be his wife. We never talked about it. It was like a rock in our sandal, ever inflicting a fresh wound.

Although I knew Jacob deeply loved me, through the years I still hadn't borne him a child. Was God punishing me? For what? I didn't know. Then I gave birth to a baby boy we named Joseph. Instantly, he became Jacob's favorite son.

My son Joseph—better than all his half brothers—muscular, polite, sensitive, and intelligent. I pour all my adoration, except for Jacob, of course, into this wonderful son of mine. Jacob even now is fashioning a coat of many colors just for him. The other boys don't like him much, I fear. He is a dreamer and a cut above their roughness. I feel this boy, our son, is someday destined for greatness. (Genesis 29, 30)

Note: Joseph was indeed destined for greatness, although his mother did not live to see it. He became second in command of Egypt and thus saved his father, brothers, and their families from a far-reaching, devastating famine. His mother's focus in training him for God served him well. Rachel died giving birth to another son, Benjamin, whom Jacob loved into his old age.

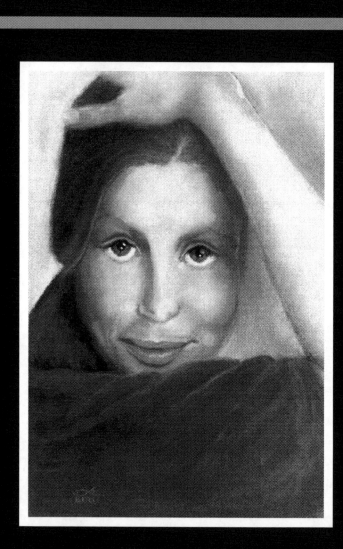

Rahab, the Curious

Rahab, the Curious

I draped my favorite sash around my waist, one the visiting Canaanite had brought me, fastened the ivory earrings, and slipped a slim hand through the golden bracelets. My long, dark hair fell below my waist. Pulling back the shutters, I gazed through the open window to the miles of desert across the Jordan.

An unusual silence drifted across the city—as if the city was waiting. *For what?* I wondered. I busied myself brushing my long locks. I loved my hair. Others did too. I looked out the window again. Somewhere out there an army advanced toward our city. I had heard the rumors. My people were terrorized by this army. When Israel invaded surrounding cities, they fell. Their God fought for them. I wondered about their God, *What makes him different?*

The thought came back throughout the day, *Who is this God?* Our gods didn't do much. I also wondered about their men. Were they like the men I knew? the men who came to me in the dark of night?

That evening I heard a knock at the door. When I opened it, I knew it must be "them." Two men stood there, two men not of my city, strong and good looking.

"Come in," I cooed. The urgency in their voices wiped out the smile in my inviting eyes.

"Do you have a place where we can hide?" they whispered. Spies! My breath caught in my chest as I bade them enter. Our soldiers

were searching for them along the roads and had shut the gates of the city, they told me in hushed tones. Escape was impossible!

"But you won't be safe, even in my house, for long," I whispered back. Their army would take the city within weeks. Their voices were matter-of-fact, their eyes pleading. Caught between impending doom and betraying my city, I hesitated only a moment. Still, I would be betraying my people—but they didn't value me much anyway.

I pointed toward the roof where the men could hide under bundles of flax.

Before the two spies went to sleep, I slipped to the rooftop. I begged them to save me, my parents, my brothers, and my sisters. I told the men I knew that their God protected them and won their battles. I wanted them to know that I was beginning to believe in their God.

"I have nowhere to go," I implored, "I will be killed either by my own people or by your soldiers." The men promised me and my entire family safety. If I would put a scarlet cord in my window, it would signal the army to spare us when the army conquered the city.

The next evening I heard the sound of rough soldiers' steps and pounding on my door. As I slowly opened the door, the soldiers ordered me to bring out the men they knew were hiding in my house.

"Two men *were* here," I explained innocently, with a sly little wink, "but they left at dusk to go to another city. If you hurry, you might catch them." I breathed a sigh of relief as the soldiers hastened from my door.

I then knew the spies were no longer safe with me.

"You must escape to the hill country beyond our gates, or you will be discovered," I urgently told them. In the dark early dawn I let them down with ropes from the upper window, watching to be sure no guards lurked in the shadows. That morning as I put the scarlet cord in the window, I wondered how their God would maneuver the battle.

Several weeks later, I heard warriors marching around my city. Their God fought the battle for them, just as they had said, and in a very strange way. But that is another story. The walls of Jericho

crumbled under the army's shouts of praise to their God. My house, built in the wall, was the only one left standing.

The soldiers took me and my family to live with their own people, a people with whom I have found a home. And—their wonderful God has also captured my heart, a God I am learning to love. (Joshua 2)

Note: Rahab later married Salmon. Their son was Boaz, the man who became Ruth's husband. Rahab is mentioned in the genealogy of Jesus the Messiah and mentioned again in Hebrews 11 as one who had great faith.

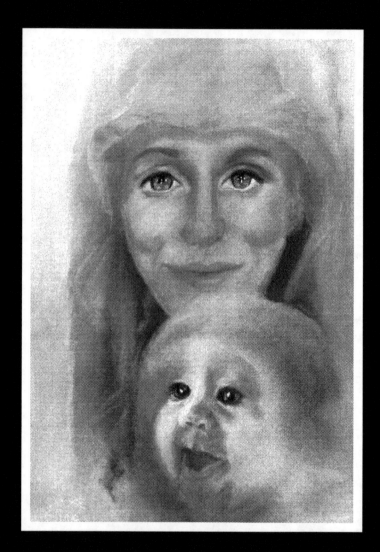

Hannah, the Longing Mother

Hannah, the Longing Mother

I n my husband's arms I lay many nights, sobbing myself to sleep, my heart longing, my soul empty. My husband deeply loved me and tried to make me happy. My marriage fulfilled me except for my heart's dream—a child. Only those who also have longed for a little one to hold and nourish know how I felt.

My wonderful husband said to me, "Am I not as good to you as many sons?" But my husband's love wasn't enough, not in our society, where a woman's value grew according to the number of children she bore. Being a good mother was vastly important to me. I felt looked down upon in my social circle—as if I were under God's curse. I shouldn't have, but I envied other mothers playing with their children. Many nights I sat up all night and prayed for a child.

One hope I held: if I could go to the tabernacle and pray, perhaps God would then hear and answer my prayer. On our next visit, while other mothers herded their children toward the camping areas, I crept to the outer court the tabernacle. *Why? Why? Why?* The question rang in my ears and like an arrow tore jagged pieces from my heart. My knees sank to the ground. I lay, my face in my hands, crying.

Seeing me, the priest thought I was drunk and asked me to leave, but upon studying my face, he realized a deep sorrow shadowed my tear-rimmed eyes. He asked what was wrong, and I poured out my heart to him, words tumbling over one another. He listened. He

really listened! What I said must have reached his heart. He seemed to understand. He prayed for me and pronounced a blessing upon me. My heart leaped. He actually blessed me!

I journeyed home full of hope and opened my arms of tender love to my husband. In a few months I was with child, my heart elated with fullness.

After the appointed time, my son was born. We called him Samuel, the baby I had promised God I would dedicate to him. With love and care, I trained my little boy, and then, even though he was young, my husband and I took him to the tabernacle and presented him to the priest.

Samuel is the joy of the old priest's life. I can tell when I visit him that he is a boy the old priest truly trusts and a boy who deeply loves and honors God.

Each year I hand-fashion a coat and take it to the tabernacle. I get to spend a little time with my son. Yet God has remembered me and my longing for children. He has given me five more children, three sons and two daughters. My life overflows with gratitude.

But Samuel, my firstborn—he is an exquisite gift from God. (1 Samuel 1, 2)

Note: God especially called Samuel to become a prophet, and he became one of the greatest prophets in Israel.

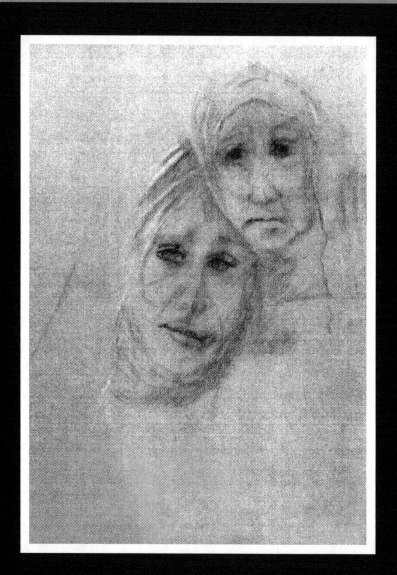

Ruth, the Beloved Poet

Ruth, the Beloved Poet

A s she walked away, I saw tears in her eyes too. I couldn't bear parting from this woman who gathered my heart to her as a mother. I ran to her and embraced her.

"Entreat me not to leave you, nor to return from following after you. For your people shall be my people and your God my God." My words, both a prayer and a poem, flowed from deep within my heart.

She encouraged me to compose songs and poems. She brought out the best in me. How could I live without her?

"Don't go," my wounded heart cried again. I could not utter a last goodbye to my mother-in-law, Naomi, as she prepared to return to her homeland and her people. Both of her sons, one my husband, had died in this foreign land, where they had come because of a famine in their own country, leaving Naomi and me alone. As our existence became more difficult, her thoughts had turned toward her home country.

She paused and held me from her, looking into my grief-stricken eyes for a long time, and then she nodded yes, a slow smile touching her lips. I put my arms around her, too full of emotion even to smile. I was going with her, to her people and to the God she and her son had taught me to worship.

Back in her own country, life got better for us. My mother-in-law, a very wise and resourceful woman, sent me to glean our food from the fields of Boaz, the wealthiest man in the village and a

next of kin to us. Oh, but I didn't go dressed as a peasant girl, oh no. Mother Naomi gowned me in the best clothes we had. I sensed she was up to something. She said to glean near Boaz, so he would notice me. He did. I caught his glances coming my way—often.

One morning she came to me and said it was time. *Time for what?* I wondered.

It seems her people had a custom that the next of kin could marry a deceased relative's wife so the family name would continue through sons born to the couple. That day when I went to work, she told me to note where Boaz would be sleeping, as he slept in the fields with his workers during harvest.

That night Naomi, like a doting mother, fussed over me as I bathed and dressed in the most beautiful gown she could find. She even provided sultry, warm spices to scent my body. After dark, she told me, I was to carry a blanket and slip quietly into the vineyard, keeping out of sight. When Boaz was fast asleep, I was to lie down at his feet and cover them with my blanket.

Never had I heard of anything like this! What if he threw me out of the vineyard and told me never to return? What if the other girls saw me? Nonetheless, I respected my mother-in-law enough to do as she said.

Fear of rejection, eagerness, and excitement struggled through my mind that night as I lay at the man's feet. This was an adventure! Needless to say, I didn't sleep. I barely breathed!

You should have seen the look of surprise and puzzlement on his face in the early morning when he discovered me. His questioning glance turned to a pleased smile when I told him that Naomi had said he was next of kin and could take me to be his wife. In return he told me there was one kinsman closer than he, and he would talk with him. Then he sent me home before anyone discovered me. I was scared, really scared, that perhaps the other kinsman would take me. I *was* rather attractive, but I felt I could never love another man again. Yet I felt warm love gently surfacing for this godly, protective man, Boaz. The waiting was terrible; I didn't know what would happen.

Boaz spoke with him, but the man declined the offer to take me as his wife. He already had a family of his own and didn't want the responsibility of another one. (My suspicions are that Boaz did a little bargaining here.) I was elated when Boaz asked me to marry him.

Boaz and I now have a son who is the delight of Mother Naomi's life. She holds him on her knees and sings to him. He is the joy of my life too, along with my husband, of course. I have one clever mother-in-law—and one wonderful God. (Ruth 1-4)

Note: Ruth and Boaz's son was Obed, grandfather of King David and great-grandfather of King Solomon, Bathsheba's son, and an ancestor of Christ.

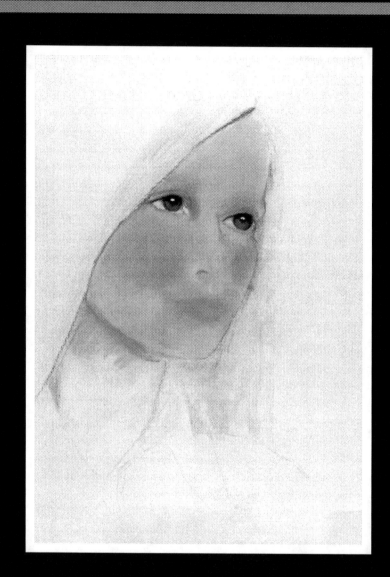

Temple Girl, God's Own

Temple Girl, God's Own

As usual, I ran to meet my father, a military leader, who had won a great victory in battle and was returning home that day. With outstretched arms I hugged him, but instead of a happy smile, his face held an expression I couldn't understand. If I had listened, I could have heard his heart break.

He quickly withdrew from me and walked silently toward the house, not looking at me. When I asked what was wrong, he didn't answer. Going immediately to his room, he stayed there a couple of hours.

When my father came from his room, he took my hands and sat me at the table. He had vowed to the Lord that what greeted him first would be sacrificed or dedicated to the Lord. Usually, father saw one of our animals, such as a sheep or cow, and he would give it to the Lord, much like our tithes and offerings. But this day, I was the one who had greeted him first. And my father would not disclaim a vow he had made to God.

My mother broke into loud wailing. I was confused—I didn't know what it all meant. My father explained in a halting voice that, in this case, to be dedicated to the Lord meant that I would never marry and would serve the Lord my entire life.

My stomach knotted. My heart thumped. My eyes blurred as sobs shook my body. I had waited and looked forward all these years to a home and family. Every Hebrew girl did. A special basket kept cherished treasures for my wedding. My girlfriends and I gave

each other gifts for our anticipated weddings. Now my arms would never hold my lover, my husband. My body would never nourish a child.

"Why? How could you?" I demanded, angry at my father, angry at a God who would allow this. What did all this mean, anyway? I knew better than to be rebellious. And I couldn't run away—there was no place a girl could go.

And yet, I had been taught to trust in God, and my father was a spiritual man, led by God. I would not rebel, I promised myself.

"My father," I comforted, "it will be all right. You have given your word to the Lord. Do to me just as you promised. I am willing." Those were the hardest words I ever spoke.

My father granted my request to take two months and visit my girlfriends, the ones I had dreamed with about our futures and our secret wedding plans. We talked and wept together because I would never marry. I told them goodbye—goodbye to happiness, goodbye to dreams, goodbye to love and a family.

Then I was dedicated to the Lord to be his, to work for him. Actually, it was a privilege, although I didn't know that at the time.

I'm not sure when it happened, but I have become more peaceful, less disappointed, and the empty feeling has dimmed. Somehow in the quiet times with God—quiet times I eagerly look forward to now—I don't feel rejected. Looking back, I realize that the God who watched over my life from the shadows has given me a special mission of service to women and children. I get to hold children, play with them, and counsel with their mothers. They are my family. What I viewed as a curse, God has turned into a blessing.

My life reflects the beauty around me. I pray to God in the cool of the evening on the desert sands and commune with him in my mind and heart. I thrill to his handiwork in nature and notice his care for the people I serve and love. And—I am keeping my father's vow.

Note: Some of the modern translations of Judges 11:29-40 say this unnamed girl remained single all her life. At the time, she didn't know about God's promises to those single, divorced, widowed, or orphaned. "Your maker is your husband" (Isaiah 54:5). "When your mother and father forsake you, I will take you up" (Psalm 27:10). "A father to the fatherless, a defender of widows . . . God sets the lonely in families" (Psalm 68:5, 6). God shared these promises with his people at later times. Yet the God who made these promises was there for a lonely girl who would have chosen another pathway.

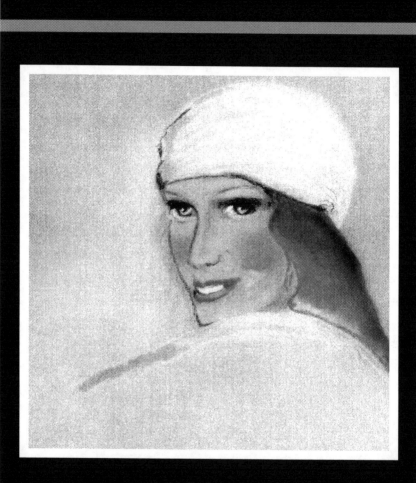

Delilah, the Betrayer

Delilah, the Betrayer

One glimpse of him took away my breath. Bronze muscles rippled in the sun, his every step strong and powerful. His hair, thick and dark, fell to his waist, almost like a cloak.

I'd heard about him. Who hadn't? Samson's great strength was renowned throughout the country. He fought Philistine soldiers and won. He played tricks on them and outwitted them. A judge, a prophet, a man of God—but not the god of the Philistines. They worshipped many gods, especially Dagon, whose magnificent temple graced the nearby city.

Each time I saw him, a shock of emotion slithered through my body. I slipped through the crowd and positioned myself where he would notice me. He did. His eyes followed me until I lost him in the crowd. He would return, I knew. I would wait. A man of God? Really? In my arms he would be like any other man, burning with desire for me.

For many days, I played the game, lingering in the shadows and disappearing. I knew he would eventually follow me home. One evening as the shadows crawled into dusk, I heard a cough outside my tent door. There he stood—even more handsome close at hand. I calmed my beating heart and with my most beguiling smile invited him to enter.

Thus began nights of ravishing—if forbidden—love, forbidden by his people and his God. I found him not only strong with rugged

good looks, but also a man of warmth and tenderness. Our visits became more frequent as I wrapped my coquettish playfulness around him, securing it with admiration and flattery. He resisted neither my smile nor my firm body. In my presence he forgot his struggles to help his people. He had no cares, just total pleasure.

The Philistine leaders noticed my enticement with the enemy. He annoyed them—the firebranded foxes he turned loose in their ripe fields, his puzzles they never solved. If I could discover the secret of his great strength, they told me, they would make it worth my while. I ignored them. They persisted.

Then the question began nibbling at the edges of my mind. I began to wonder: *Will he really divulge his secret, a secret between him and his God?* It became a fun pastime, a game between us. I'd smile, tilt my head, and ask in my little-girl voice, "Samson, why are you so strong?" And he would tell me, once to bind his hands with green limbs, another time to weave his hair in a loom. Then I'd shout, "Samson, the Philistines are upon you!" And he'd break the bands or pull his long hair out of the loom.

The Philistine leaders came again, this time with an irresistible offer—enough money for a lifetime of luxury. That night I prepared treats of bread, figs, and raisins, his favorites. As we lay in the moonlight, I again coaxed, "Samson, if you love me, tell me the secret." He looked deeply and intimately into my eyes, his look asking if he could trust me, and simply said, "My hair has never been cut." I put my arms around his neck, and as I caressed his face, he dropped his head into my lap and slept.

I picked up each magnificent lock of hair and cut it. Then I stood and shouted, "The Philistines are upon you!" He awoke just as soldiers jumped from their hiding place outside my tent and bound his hands and fettered his feet. He struggled—his powerful strength gone!

As I stood in the tent door, the soldiers jerked him outside and gouged out his eyes with a sharp stone. I screamed, but they only guffawed and threw the money at my feet. Tears ran down my own cheeks, as blood flowed down his. I—I had betrayed the man who

loved me. As he stumbled away, he turned his head toward me, and I heard him whisper one word, "Delilah." (Judges 16)

Note: Samson became the prize and sport of the Philistine nation, a nation he had once fought against and won. His God, his strength, had departed from his life, but not from his heart. As he stood chained between massive pillars in the Philistine temple, Samson's last request of God was that God would restore his strength once more. God honored that request. Judges 16:30 says that as Samson gave a mighty heave and crushed the pillars that brought the temple down he killed more in his death than in his life. It is not recorded whether Delilah was among the dead.

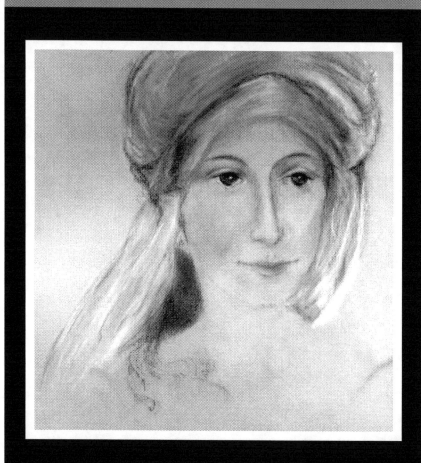

Deborah, the Brave and Strong

Deborah, the Brave and Strong

W e were in trouble. For 20 years Jobin's general, Sisera, harassed us with his 900 chariots of iron drawn by horses trained for war. With these chariots, soldiers ran over our people, damaged our crops, sacked our towns, raped our women, and escaped, often carrying our children off as slaves. All this happened because we had stopped following the true God, the One who had freed our ancestors from slavery and given us this land.

As Israel's judge, I held my court under the Palm of Deborah, between Ramah and Bethel. Israel didn't have a king in those days but was guided by judges of wisdom, judges close to God. My quiet times seeking God and praying for guidance gave strength to my leadership. One day, God impressed me that it was time to end the cruel rule of Sisera and his 900 chariots of iron. I sent for Barak, the man God had chosen to lead our army.

When Barak came before me, he got directly to the point: "If you go with me, I will lead the army; but if you don't, I will not go!"

I looked intently into Barak's eyes.

"Very well," I replied, "I will go with you into battle, but, you know, the honor will not be yours. The Lord will give your enemy to a woman." At that thought I smiled ever so slightly and waited.

It wasn't just lack of confidence that guided Barak's decision; he wanted to be sure of God's presence and needed a person of

sound judgment and courage to go with him. I rather thought *he* showed sound judgment in this. Yet, how could we have known then just how much honor would go to a woman—two women to be exact.

Village after village refused to join Barak—to be slaughtered, they feared. Finally, 10,000 men answered the call to battle, and Barak assembled his army. Sisera prepared his 900 chariots of iron with the fastest horses and gathered a mighty army from Horosheth to the Kishon River.

The very air felt electrified as I rode out to meet Barak, the soldiers shouting, falling in behind us, eager, and probably a little curious, too, as a woman had never headed our army before. My blood raced through my poised and tense body, yet I was not afraid.

I turned to Barak and shouted the charge: "Go! The Lord has given Sisera into your hands!" As we marched from Mount Tabor's heights, I could see Sisera lining up his 900 chariots of iron in the Kishon River valley below. *Have I come for such a time as this?* I wondered. I also saw storm clouds to the east. *Rain?* I questioned as I looked up. The dust that choked my throat and clouded my sight began to clear as rain pelted our heads and arms.

Sisera's army loomed ahead as we rushed into battle. Just before the chariots crushed us, the horses reared and snorted, mud clinging to the wheels of the chariots. Soldiers jumped from the chariots trapped in the mud and ran, only to be cut down by their own swords, snatched from them by our warriors. I observed the turmoil from the sideline, as blood flowed with the rivers of water. Screams of fear and anger and the whinny of frightened horses rose with the wind. I stood amazed at how simply God delivered our army—by a rainstorm. Not a man escaped the swords that day—except one, Sisera.

Only later did I hear the story, how he ran to the tent of a man he thought was his friend. His friend's wife, Jael, welcomed him, "Come, my lord, come right in." She gave him a cool drink, but as he slept, she crept to him and drove a spike through his head.

When Barak ran by her tent in pursuit of Sisera, she went out and said, "Come, I will show you the man you seek."

The battle was over, the victory won. God honored our faith, our willingness to put our lives on the line for him. The honor went to two women, the one who led the army and the one who killed the enemy commander. Throughout the land, our people celebrated in the streets and in the villages, in the fields and on the rooftops, with music, shouts, and praises to God.

Barak and I led the singing that told the marvelous story in song: "I will sing to the Lord, I will sing . . . in the days of Jael, the roads were abandoned, travelers took to winding paths, village life ceased until I, Deborah, arose, a mother in Israel . . . Most blessed of women be Jael, most blessed of the tent-dwelling women . . . She crushed Sisera, at her feet . . . and there he fell, dead. . . ."

I ended my song with these words: "So may all your enemies perish, O Lord. But may all who love you be like the sun when it rises in its strength."

Note: Under Deborah's wise leadership, Israel enjoyed 40 years of peace. Her story is found in Judges 4, her song in Judges 5.

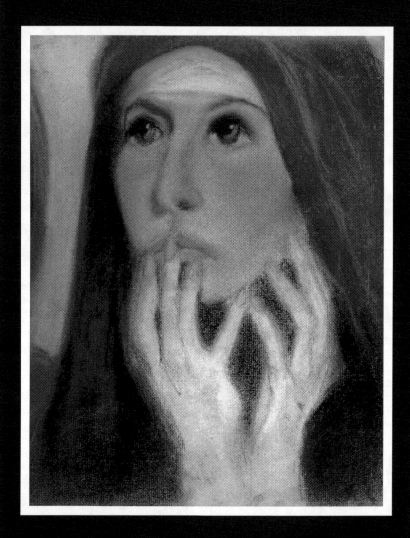

Abigail, the Gracious Woman

Abigail, the Gracious Woman

My husband stared defiantly at me. *How could he have done that?* I thought. He had been drinking so much he didn't know the consequences.

My husband had sent an impetuous message to King David and his army declaring he would not provide sustenance and water for the tired warriors. He would not even permit them to cross his land! Didn't my husband know David would probably attack and kill us all?

Such a simple request. Now they would have to go miles out of their way, foot weary, tired, and thirsty. King Saul, who occupied the throne, hunted King David, the newly anointed king of our country. David and his army wandered the desert fleeing the wrath of Saul, who would not consent to David's kingship. David's reputation as a warrior spread well before him—a strong leader with a brave, fighting army.

My heart tightened, my stomach lurched. I made a quick decision—I, who now had to make most of the decisions, run the household, and manage the servants, while my husband merrily drank his days away with his buddies.

When I had consented to become his wife, he was charming, strong, and handsome. We threw countless parties and feasted with a multitude of friends. But now he was fat, surly, rude, and usually drunk.

Our household would be in grave danger as David and his warriors advanced, probably to annihilate us.

Quickly I had the servants gather baskets of bread, figs, and jars of water for the thirsty soldiers. My drunken husband never knew.

What a long, hot journey! We rode our heavily laden donkeys in the dust and heat. I almost gave up searching for David and his warriors.

Then I saw the dust speck in the distance that grew larger, developing into men wearily placing one foot in front of the other. They halted in amazement. We must have been a sight—one lone, beautifully dressed but dusty woman with a few servants, leading a herd of donkeys laden with food and water. We stopped, and I jumped off my donkey, my hands trembling, my heart filled with fear. I ran to King David, bowing several times.

He accepted my gifts, his questioning eyes trying to hide his amusement. I hoped we had brought enough, as the gaunt men gulped the water and grabbed the food, not waiting even for us to leave. Never had I seen men so hungry. And I saw gratitude and admiration for me in David's eyes.

When we returned home, it wasn't long until I heard mourning and wailing as if someone were dead. Someone was—my husband. He had fallen backward from his couch and died, probably in a drunken stupor.

King David waited until my days of mourning were over, according to our custom, and then sent a runner with a message inviting me to be his wife.

Amazing! Because of one act of kindness I became a queen. I didn't do it for that reason. I did it to protect my husband and our home. I also did it for David and his men, because I didn't want them to be without food and water.

I accepted my position of queen with joy. David gained the throne to become Israel's most beloved king. He calls me his gracious, beautiful lady. We worship our God and sing psalms David himself writes. My favorite phrase is "my wonderful One who lifts up my head." David, my hero, has also lifted up *my* head. (1 Samuel 25)

Note: One of my favorite biblical women, Abigail displayed great courage in the face of her husband's probable anger and David's possible rejection. A woman of executive skill and a decision maker, she is compassionate, a woman beautiful and gracious—so much so that she won the heart of a king.

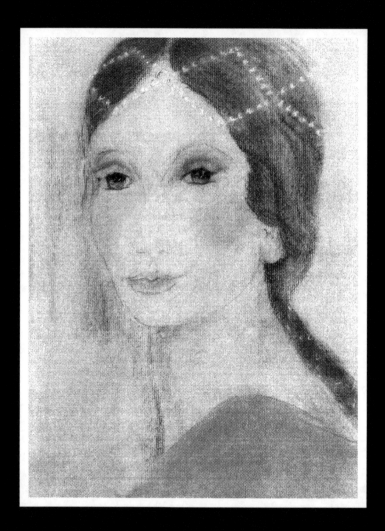

Esther, the Beautiful Queen

Esther, the Beautiful Queen

W hat did they mean, these messengers riding through the villages on steeds with golden saddles seeking the most beautiful girls to be a part of the king's court? I, beautiful? My uncle, Mordecai, said so. Intelligent? Yes. He said that, too. He raised me to be compassionate, to care whether the small children next door got the food they needed, yet to overlook my own hunger when necessary. He also taught me to be strong and make hard choices.

A peasant girl, I saw invaders kill my parents and conquer our land. Raised by my uncle, I sensed his love and respect. He treated me as if I were his own daughter. He taught me to love his God—a God that is our life and the length of our days.

At first I didn't want to go with the messengers, but my uncle explained the great honor and said he would visit me often. Besides, he let me in on a secret. The king was searching for a new queen.

So I traveled with many other girls to join the king's harem at the fortress of Susa, in Persia. There servants pampered me with silk gowns, perfumed baths, and delicacies I never dreamed existed. I experienced the luxury of woven hangings over my bed in my very own room. Yet I kept my nationality a guarded secret.

When my turn came to go to the inner court, my guardian, Hegai, oversaw all preparations, six months of beauty treatments and an additional six months of having my skin oiled with sweet spices and perfumes. I followed his every suggestion. The servant girls robed me in multicolored silk. Then I came before the king in his glorious palace— window hangings of green and blue cotton fastened with cords of purple

and silver. Couches of gold rested on white marble. Although I was quite overwhelmed by it all, I kept my composure.

When I was returned, not to my quarters, but to an exquisite gold palace, I knew I had been selected queen. Hegai later told me that when he first saw me among the peasant girls, he knew I would wear well the qualities of a queen. It was more than beauty, he said, it was my confidence and serenity—qualities I remember my uncle emphasizing.

I wanted to be the best queen King Ahasuerus could ever desire. And the months of training in court ways served me well. Through the months that followed, I sensed that the king truly loved me. He told me I had developed from a beautiful girl into a mature, lovely, and elegant woman. After our evening meal, we often sat and talked for hours. He seemed to value deeply what he called my discerning mind and consulted me about important courtly decisions.

During this time my uncle often came to visit me, yet he never revealed our relationship to those at the court. One time, heaviness enveloped him. His quiet pensiveness seemed totally out of character. When I probed, I learned the king had decreed my people's death on a certain day, all because my uncle refused to bow down to Haman, the king's top man, a haughty official. Because of this, the official surreptitiously instigated a death plot against my uncle and all Jews, our people. A just man, my uncle held his convictions tightly. If he believed bowing down to anyone except God was wrong, no one could persuade him differently.

"Esther," he said, his keen eyes searching mine, "you must go to the king and ask for his help." He, as well as I, knew the danger. For anyone to enter the presence of the king uninvited could mean death. And I would have to reveal that the Jews were my people, a secret I had diligently kept. But I had to try. My uncle said he and his friends would be praying for me.

I couldn't sleep that night. My heart wrestled in prayer with the challenge and the danger. Then my thoughts cleared and a plan came to me. I would invite the king and that haughty official to a private dinner. The king reveled in how I ran his household, directed the servants, and had exotic food prepared for him. Perhaps he wouldn't refuse me.

With a prayer in my heart and the confidence and bearing of a queen, I stood before the king, carefully concealing the fear in my heart. I held

my breath. He held out the scepter to me. He accepted the invitation to my feast, the best one I had ever hosted. Food from faraway places, flowers, and palm fronds graced the table. Harps, flutes, and flickering lights created the intimate setting the king had grown to love. I never expressed my beauty as I did that night.

We visited, the king, Haman, and I, enjoying every dish of the exquisite dinner. Before the two men left that night, I invited them back the next evening to an even more magnificent feast.

The second evening, the king and Haman relaxed even more. Even though the king adored me and trusted me, I could tell by his glances that his curiosity was growing. Sure I desired something, he asked again, as he had the first evening, "What is your request, Esther? I will honor it, even to half of my kingdom."

I could contain myself no longer. I dropped my head and wept bitterly. As the king consoled me, I told him of the plot to kill my people, a plot instigated by his top official, and I pointed to the chief officer. The king's eyes darkened with rage.

"I will take care of this immediately," he roared as he ordered his soldiers to drag the man away.

The next morning at dawn the chief officer hung from the gallows he had ordered made for my uncle. Soon the decree went out that my people could defend themselves against those who desired to kill them at the appointed time. My people did not die that day.

I trusted my God, and he brought us through. Looking back, I can see God watching from the shadows my life, working to avert the threat to our people. I remember my uncle's words, "Perhaps you have come to the kingdom for such a time as this." (Esther 1-10)

Note: In the city of Hamadan in northwestern Iran stands a mausoleum that houses two tombs. Beneath its simple brick and stone dome, with Hebrew inscriptions on the walls, are an entrance, a vestibule, a sanctuary, and a Shah-ni-shin or king's sitting place. According to one tradition, this site is believed to be the graves of Queen Esther and her uncle, Mordecai.

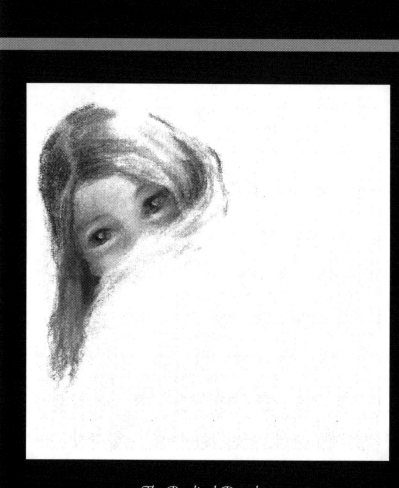

The Prodigal Daughter

The Prodigal Daughter

I t is a wonderful story about my "big brother," my lover, my husband. But I didn't realize it at the time—you know how teenagers sometime take everything for granted.

I loved my growing-up years. My big brother delighted in picking out for me the most exquisite gowns, linen, silk, and embroidery. He bought me extravagant jewelry—but I'm getting ahead of my story.

You see, he really wasn't my brother. I was adopted. He rescued me.

He found me out in the desert on an early-morning ride on his white Arabian stallion. Actually, his Egyptian hound, a Saluki, found me, only a few hours old, partially hidden under a rock, wrapped in bloody rags. I think my mother had tried to bury me. Sand covered my mouth. Sand clung to my body.

His magnificent heart took pity on the little abandoned bundle, and he hurried me home to his father. They lived together in a huge mansion amid palm, cedar, oak, and olive trees. Graceful horses pranced in their stables.

From the beginning, the son wanted to keep me. His father later adopted me and obtained a woman to care for me. I grew up in an atmosphere of beauty and love. Father and son delighted in me, and I followed them everywhere—from room to room, outside along the orchard trails, even in the stables. They'd hold my little hand and often stop and give me a big hug. But as a teenager, I became restless. Out there in the world beyond, were there more exquisite places to explore?

In my late teens, I noticed the son's eyes grow softer and shine with a new sparkle when he looked at me, and I sensed a thrill captivating my own heart. Could this be the beginning of a new kind of love? He gave me jewels of jade, onyx, amber, gold, and silver. He knew all my favorite gems. We spent time together, walking amid the gardens, or riding our horses, I on Shaka, the high-stepping mare—his special gift. As time went on, he asked me to marry him, he, my wonderful one, my magnificent one. Our wedding can only be described as every girl's dream.

One day a scroll arrived in my name, an invitation from a governor in a town not too far away. I sneaked to the stable, mounted Shaka, and rode away, but I didn't tell my husband.

Nothing happened except that I tasted delicious pomegranate wine and men admired me as a gracious lady. Thus began the first of many rendezvous, innocent, of course, at first. Then I began getting invitations from farther away, and my life became a whirlwind of dinners, parties, and flirtations. Admired, enticed by flattery and jewels, entertained by valiant warriors and powerful kings, I became the Jewel of the East, the reward of wealthy men.

I didn't exactly forget my first love, but always one more adventure beckoned. One more lover's invitation squeezed out any quiet moments to think. And when I did think, I felt I could never go home again, never be forgiven.

Through a series of adverse events, I had to sell my precious jewels, one by one, and eventually my beloved mare, Shaka. In my heart, I realized I had never found anyone who loved me as did my husband; although now I searched for this kind of love from city to city, through dusty streets and dirty buildings.

One evening as I wearily lit an oil lamp and sat alone by the window watching the sunset across the desert, I heard a knock on the door.

Slowly I opened it. There stood my big brother, my husband, my friend. No words can portray the emotions I felt—fear, shame, love—all trampling my heart. I longed to bury myself in his arms. Fear wanted me to run far away. Instead, I cautiously invited him in.

His last memory of me was of a beautiful, happy young woman with laughing eyes—eyes now clouded and tired. Instead of a woman clothed in graceful gowns he had given her, he now stared at a gaudily dressed harlot.

I led him to the table with the one flickering light. He asked why, why had I left? And I felt the hurt I saw in his eyes. As I told him about my life, he asked questions. I gave honest answers. His eyes darkened with anger as he expressed betrayal over my leaving. His anger went on and on. He walked out into the cold night air, leaving me alone, and I put my head in my hands. Minutes passed—eternity, it seemed. He quietly slipped back in and sat down. I heard him draw a long sigh; eventually I looked into his eyes.

"I remember you as a little girl following me everywhere," he began, "you as my wonderful wife, loving me." He sadly turned his head away. "My father and I always loved you, with a love that never let you go. You were always on our mind."

I couldn't believe his words, not after all I'd done.

He stood, helped me to my feet, and took my shoulders in his strong hands. He looked deep into my eyes until he knew I understood, his love connecting with my soul.

Then he said the sweetest words I've ever heard, "My darling, I forgive you. I renew my marriage covenant with you."

I buried my head in his strong, comforting arms. My tears flowed. I was home. (Ezekiel 16:1-19, 59-62)

Note: This is the story of the prodigal son all over again (see Luke 15:11-32), but this time it is a woman instead of a man, and in the Old Testament rather than the New. It is the story of a heartbroken, angry, yet compassionate God, seeking his beloved. It is the story of God's love and grace to each of us, told again in another way.

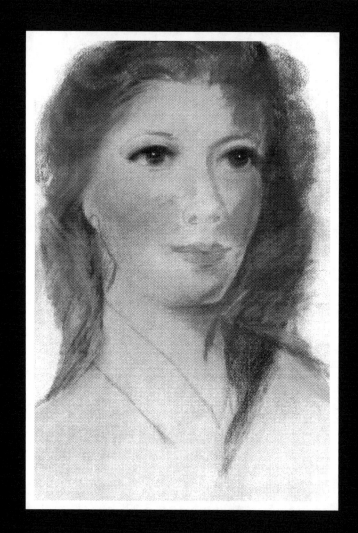

Gomer, the Reluctant Wife

Gomer, the Reluctant Wife

I paced back and forth on the slave block. My ankles ached from the weight of the chains, my once-lovely shawl torn and dirty. I felt men's eyes staring, ever staring, and I looked back with rebellious eyes.

I remember my first love, how his dark, ravishing eyes roamed over my teenage form, as many times I sneaked from my parents' home to meet him alone on the desert, allured by my awakened feelings. He brought me trinkets, and from the East, jewels. He let me ride with him on his Arabian steed, a horse black as midnight and fast as the wind. Then one day he invited me to go with him, far away from my parents' home, to be his cherished woman. I didn't hesitate, for he had captivated my heart. He pampered me and called me his "kept" woman. Then one day, he vanished. I waited, but he never returned; I buried the ache in my heart along with his memory.

Of course, I could take care of myself. I had learned my lessons well, how to seductively smile, walk, and flatter. I moved with sinuous grace. But as always when life wrapped me in pleasure, something happened. My lover became angry with me and bartered my beauty to the slave traders.

On this day, as I walked on the slave block parading my body before leering men, I noticed a rather plain man watching me, his eyes serious, kind, and almost innocent—not the type who would buy or even want me. But he paid my price and took me home

to be his wife. Seriously! I didn't know anything about cooking, cleaning, or raising the two children I eventually bore. Hosea, my husband, patiently and kindly taught me, but he journeyed to faraway places as a speaker for his God, a God he greatly loved.

Oh, how I missed the luxury, the gorgeous gowns, the attention I once knew. I tried to forget, but thoughts trampled on my mind until I packed a basket and by morning I was gone. The children would miss me. I knew they'd be in good care with their father.

Life became what I envisioned for a while, but then it turned dark. My man beat me, starved me, and brought other men to me. I hated my life. I ran away, but he captured me and placed me once again on the slave block.

The man with the serious, innocent eyes, my husband, bought me again and took me home. He gave me gifts and tenderly loved me. I tried to be a good wife and mother—I really did—but the mundane life of cooking, washing, sweeping, and taking care of the children dampened my soul. I didn't have friends; the women kept aloof from me. My mind struggled; images danced in my head. Powerless against the pull of my passions, against the anticipated flattery of men, eventually I slipped away again.

With this venture, there were no good times—existence turned bleak. As I was paraded again on the slave block my spirit broke, my heart died. Then I heard a whispered word: "Gomer?" It was my Hosea. I didn't look up. Out of the corner of my eye, I saw him walk over and pay my price—a price I knew I wasn't worth. It took all the money he had.

The chains they cut from my wrists clanked to the ground. I expected him to chain me again, but instead, he said, "You're free. You may go, but I'd like for you to come home with me." I turned to walk away, but curiosity enticed me, so I followed him home—at a distance.

The children wrapped their arms around me. I hugged them for a long time and then turned to him.

"Welcome home, my love," he said, and his tired, kind eyes smiled. "I've always loved you. I've searched for you." His voice reflected no condemnation, no mention of my past.

"Your God asked you to do it, didn't he?" I asked. It was more a statement than a question.

"Yes," he acknowledged. I remembered how he had gathered the children morning and evening to worship his God, while I had remained aloof.

After a long silence, I took his hands in mine.

"Teach me," I pleaded, "how to love. Teach me how to forgive. Teach me about your God." (Hosea 1-3)

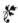

Note: This is one of the most beloved stories in the Bible, a story about the love of God for each one of us.

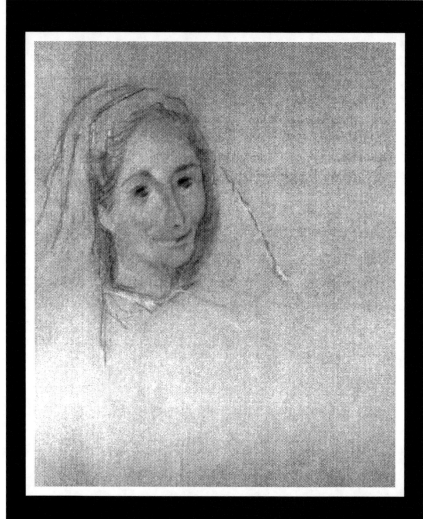

Anna, a Woman After God's Own Heart

Anna, a Woman after God's Own Heart

I observed them as they lingered quietly in the shadows of a large column. She appeared so young as she reverently held her baby, and he, taller, much older, expressed such tender regard for her. He placed one arm around the young woman's shoulder. In the other he carried a stick cage with two turtledoves, like many other poor couples who brought their newborn to be dedicated at the temple.

Something about them drew my attention. Something I had heard, perhaps? Or the revealing of God's Spirit? I sensed this was no ordinary couple.

I had no family. My love, my husband, died many years ago, after only seven years of marriage. Days spent at the temple, serving and praying, comforted me. I had spent hours in study, searching the Scriptures, and listening to wise ones talk. I had known the time was approaching; those of us who studied the prophecies knew.

At a distance I followed the couple, standing back from the doorway as Simeon, a devout man of God, held the child for blessing. My ears and my heart heard amazing words. Blessings and proclamations poured from his lips. This aged man had once told me God had revealed to him that he would see the Christ before he died.

I heard him say, "Lord, I'm now ready to die in peace." He lifted his head in triumph and continued. "I have seen your salvation for all people." I noted his emphasis on "all people." The young woman and her husband beamed, looked at each other, and nodded. They knew. Then, bending nearer, Simeon spoke softly to the mother, perhaps to comfort and encourage her for the unknown path she would travel, often filled with pain and hardship as her bruised heart entwined with that of her child.

Then I knew. This tiny baby was the long-awaited Messiah, the Christ. I cannot describe the joy that gripped me in that moment. Hundreds of years my people had waited, longed, and searched for the "One to come."

I moved forward, gently enveloping the child in my arms. I remembered the words I'd read many times in the book of Isaiah, "The Wonderful Counselor, the Mighty God, the Everlasting Father, the Prince of Peace" (Isaiah 9:6). He will bear our grief and carry our sorrow. The Savior for us all. I gazed in wonder at this tiny baby, our long-awaited Messiah.

As I held Him, I knew I was the one especially blessed. God had trusted me with this moment. Time stood still and eternity touched earth. The joy of a lifetime flooded my soul, and I was at peace. (Luke 2:36-40)

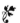

Note: Along with the shepherds and the Wise Men, Anna, more than 80 years old at the time, was one of the first heralds of the Good News. She quietly spoke about the child to those in Jerusalem who were looking for the Messiah.

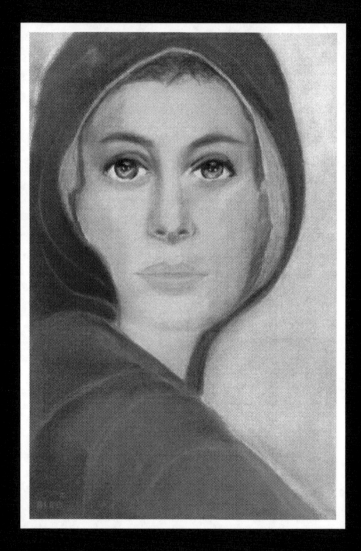

Woman at the Well, the Seeker

Woman at the Well, the Seeker

Hot, miserable heat smothered me as I set my heavy jug on the edge of the well and drew a deep sigh. Water, how precious to our sandy land. Through dust kicked up by the wind, I saw the stranger sitting on a rock, travel weary, and obviously a Jew. So I lowered my eyes and began filling my water jug.

"May I have a drink of water?" I heard him ask.

I drew back. He? A Jew? Asking a drink from me, a Samaritan? The Jews wouldn't talk to us and looked down on us—and even more so for me, as I was a woman. But curiosity grabbed my mind, and I edged closer.

As I handed him the jug, I noticed his eyes, warm and intense.

"Why do you ask me, a Samaritan woman, for water?" Foolish question; he was burning with thirst.

"If you knew who it is who asks you for a drink, you would ask him, and he would give you living water."

My heart quickened. I was a woman, but I was also a seeker. I listened to people talk. I pondered in my heart what I heard. I had heard about a Jewish Messiah to come. But I brought my thoughts back to the present.

"Sir," I said, "you have nothing to draw with and the well is deep. Where can you get this living water? Are you greater than our father Jacob?" I baited him with that question.

"Everyone who drinks this water will be thirsty again," he said, "but whoever drinks the water I give him will never thirst again. The water I give him will become in him a spring of water welling up to eternal life."

"Eternal life? Give me of this water," I pleaded. I could no longer contain myself; I was so excited.

"Go, call your husband and come back," he said.

"I have no husband," I replied. And I could tell by the slight smile on his face that he knew.

"You are right, but you have had five husbands, and the one you are living with now isn't your husband." I gulped; there was no way this stranger could ever have known this.

"You are a prophet?" I questioned. By now I was fascinated with this man. He talked more, telling me that the Father God in heaven was seeking followers who worship him in spirit and truth—not just in a place, like Jerusalem.

"I know that the Messiah, called Christ, is to come." I had to let him know that I was a seeker.

Then he said words I've remembered a lifetime—words that made me whole.

"I am the One."

I'll never forget the thrill that electrified my heart.

I forgot my water jug. I forgot the heat. I forgot that I needed a drink. I didn't notice my sandals scoop up the sand nor feel the stones cut my feet as I ran to the village. I told everyone I met, and they rushed out to meet him. He stayed with us for three days as we absorbed his words. He healed our sick—not one sick person remained in our village.

I asked for word of him from those passing through our village and heard the miraculous stories that followed him.

Rumor had it that he was crucified outside Jerusalem, between two thieves—but that he came to life again the third day and returned to heaven, just like the prophets had predicted. Truly he was the Messiah.

I will never forget my encounter with him that day at the well— my encounter with God. It changed my life forever. (John 4)

Note: The unnamed woman at the well was the first recorded person to whom Jesus revealed that He was Christ, the Messiah.

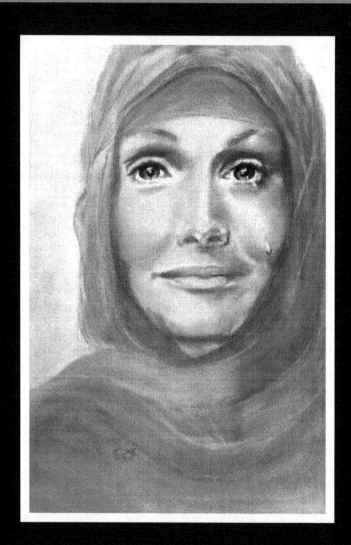

Glimpse of a Stranger, the Forgiven

Glimpse of a Stranger, the Forgiven

I huddled on the gravel, my arms burning from the fall. Looking up, I saw a blur of hazy, angry faces closing in a ring around me.

Arguing, piercing voices shouted. Sinewy fingers clutched rocks picked up from the roadway.

Some of those hands not too long before had stroked my smooth, olive skin and tousled my ebony hair. Some of those now angry voices had told me how beautiful I was and laughingly gained my confidence.

I shivered in terror as they crowded closer. More of the men picked up stones. I then noticed the stranger for the first time, swarthy from the sun, with a healthy, honest look on his youthful face.

For some reason he too seemed to be the center of the commotion, but not part of the crowd. He stood alone to one side. Some of the men shouted at him. They seemed to want him to say something or do something.

I heard the words, "Stone her! She is an adulteress!"

He turned and gazed down at me, hovering there on the ground. No anger hardened his eyes, eyes that reflected kindness, hurt, determination, and a mission. I would never forget that look.

He squatted on the ground, fingering the dust. The men positioned themselves so they could glance over his shoulder. Slowly he began writing something in the sand, his fingers tracing words—"thief," "dishonest," "adulterer," "liar." And there were names attached to those words. A hush fell over the crowd.

"He who is without sin, cast the first stone," he said, as he unflinchingly searched the face of each man standing there.

Looking up, I saw a look of consternation shadow one of the men's faces.

I closed my eyes and drew a ragged breath. I had forgotten to breathe. Feeling sick and exhausted, I dared not move. The scuffling of feet and dull thud of dropping stones echoed in my ears.

A long time passed, it seemed. I looked up once more. No angry faces leered down upon me.

Slowly I struggled to my feet. The stranger held out his hand to steady me. The place around me was empty except for the stranger. For a long moment we looked at each other, my eyes questioning, yet filled with gratitude; his eyes strong, sympathetic, and sincere.

"Does anyone condemn you?" he asked. I looked around. No one remained.

I met his eyes. Hesitantly I shook my head.

"No," I whispered.

Gently, yet full of authority, the stranger spoke, "Neither do I condemn you. Go, but don't do it again." I knew what he meant.

Suddenly a heavy, smothering burden melted from my shoulders. I would not need to covet the arms of strange men again. Here was someone who valued and respected me, who seemed to know the kind of person I so longed to be, who wanted me to give my best to life.

And—I felt he would allow me to be his friend. (John 8:1-11)

Note: The Bible doesn't identify this mysterious woman who has captured the hearts of many Bible readers. Some speculate that she may have been Mary of Magdalene, or Mary who sat at Jesus' feet, or the woman who washed his feet with her tears and dried them with her long, flowing hair, or even the Mary who was first to greet him at his resurrection morning.

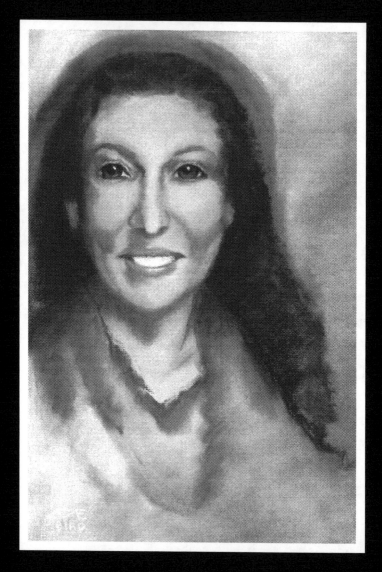

Forgotten Woman, a Touch of Faith

Forgotten Woman, a Touch of Faith

What I saw crushed my heart. Crowds, layers of people, all shouting and pushing toward the Healer. Never would I have a chance to get near, much less be made well.

Dejected, discouraged, hot, tired, and rejected, I stood leaning against one of the few trees. He stopped. People pressed around him.

I had heard about the Healer. Walking from village to village, he left everyone whole. If only I could reach him. This thought had been my companion, almost an obsession.

Then one day I heard that he neared my village. Just thinking about him renewed my energy. That morning I carefully dressed in many layers of clothing and began my slow walk to the outskirts of the town, my head bowed. People avoided me.

If only I could get close enough to touch him. Ducking my shoulders to edge myself between sweaty bodies, pushing their robes back from my face so I could see, I crawled. With determined strength I inched my way forward. Careless sandals ground my fingers into the sand. I put out my hand, but couldn't reach him. Men stepped around my bowed form, ignoring me, yet I couldn't go away without seeing him. Would he heal me? I knew he would.

I reached out again, and my fingertips barely caught the hem of his robe. New life surged through my blood. I felt happy! Alive! I only remember feeling this way as a child. I was whole!

"Who touched me?" he questioned, looking around the crowd. This couldn't be happening to me! I had barely touched his robe, not him. The men near him said rather sternly, "Everyone is touching you in this crowd."

"No, someone special touched me!"

I stood up. *Is he angry?* I wondered, my breath heavy in my chest. But his voice was kind. A hush came over the crowd. Silence.

"I did," I mumbled. He looked at me for a moment with most compassionate eyes. Then he said, "Daughter, go in peace, your faith has made you well."

He gave me back my life! I would be accepted in society again and have friends. I was alive! Alive! Alive!

Oh, to belong and to have friends. My illness, an issue of blood that never stopped, had isolated me: I was unclean, shunned by society. One year had dragged into 12. I don't know how I endured. There was no cure—none. Miserable, I had sat in my house.

Now I was well. Oh, what that touch meant to me—vitality, restfulness, confidence, and power. That look, those words of blessing, I've pondered them since that day. Those words made all the difference. They made those years of illness worthwhile—those few moments with him. (Mark 5:24-34)

Note: Can you imagine the courage this woman showed to leave her house and try to find Jesus, not knowing how her journey would end? She had heard of his miracles and compassion for people, and she took the risk because in her heart she trusted.

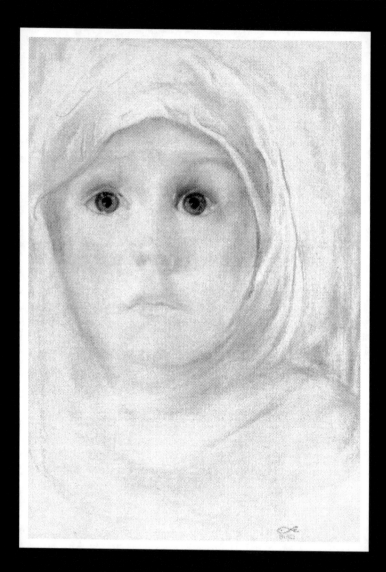

Jairus' Daughter, a Miracle

Jairus' Daughter, a Miracle

Horribly ill, I lay, a fever burning my body. With thoughts hazy I barely heard the voices in the room, hushed and sad. Mother dripped cool water over my hot, red face. As the only child of a temple officer, pampered and loved, I knew my parents adored me. My father often took me riding with him on his horses.

But now here I was, my mother at my bedside. I heard my distraught father say, "There is one who can help, the Healer." I so longed to be well. If only I could get to see this man, but I felt worse and worse. The darkness pressed closer and closer—blackness took away the voices and the soothing coolness of the water, even my breath. I fell deeper and deeper into cold, suffocating darkness that drew me farther and farther away. Time passed, but I didn't know how much.

Then I heard my name and saw a light! My eyes flew open. I found myself looking into the kindest eyes I'd ever seen, and a firm hand helped me sit up. The fever was gone! I was well. Just like that. What had happened?

My parents gasped, threw their arms around each other, and cried. They hugged the stranger, too. They were crying, praising God, and thanking the man all at the same time. My parents had quite forgotten me, sitting there feeling the wonder of it all.

The man smiled at me and then turned to my parents.

"You'd better give her something to eat," he said, a twinkle in his eye. Energy, happiness, and joy vibrated through the room.

My father later explained to my mother and me that when I no longer responded to him, he knew I was dying. He had rushed immediately to find the Healer.

"The Healer started toward our home," my father began, "but crowds of people seeking him and asking his blessing held him back. I saw many people made well. I knew he could make you well, if only I could get him to your bedside in time. I impatiently tried to hurry him along, but he seemed to ignore me, caught up with the needs of the bystanders. Then our servants arrived with the message, 'Don't trouble the teacher to come, your daughter is dead!'"

Father hugged me and choked up, barely able to talk as he continued. "Stunned, I just stood there. In anger, I wanted to shout out to the man, 'It is too late—too late! Didn't you understand you had to hurry?' But the man told me to have faith and kept on walking. He didn't even appear worried.

"When we arrived home," my father continued, "the Healer sent the mourners away and came to your bedside. He took your hand and called your name."

The rest of the story I knew. I came to life! There is no other way to say it. He gave me back my life. I'd never heard of that happening before. I didn't ask how or why; I was just beside myself with happiness. I think it was my father's faith, his never giving up.

I think my father believed in the man even before he ran in search of him. The Healer, he was more than a man; he was the long-awaited Messiah. And to think, I was one of his best miracles. (Mark 5:21-43)

Note: Don't you just love the surprised, startled look in the little girl's eyes? It's as if she is whispering, "I don't believe this! What happened?"

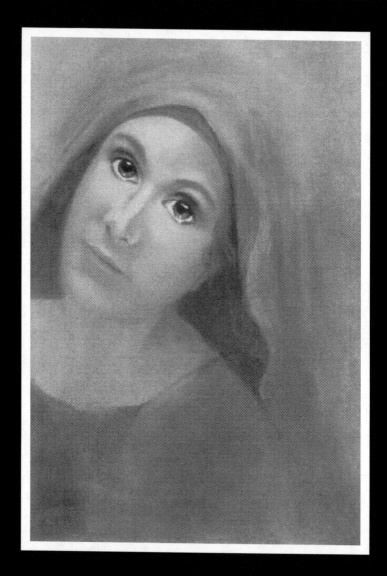

Mary, the Listener

Mary, the Listener

L istening to his words, I felt completely accepted by this Teacher who walked from village to village telling stories. In his smile I felt free. My no-nonsense brother, Lazarus, my take-charge sister, Martha, and I were among his most devoted listeners. Many a sunny afternoon found us sitting close to him on a grassy hillside, soaking up every word. I usually lingered there longer than the others.

He was drawn to us, I think, because we all were young, in our early thirties. He felt we understood his mission. Our home became the Teacher's solace, a place apart where he could rest from his travels. To him, we were family.

In him I discovered a soul mate. When he was with us, there was only one place I could be found—sitting comfortably at his feet. Enamored with his words, I let everything else drift into insignificance—both time and chores. Each story told me a little more about the God he totally loved and served. His words opened doors of wisdom.

Martha wanted the house and meals perfect, his every need cared for. I helped when she asked, and then slipped back to him. But she did have to ask, and I think that was what irked her. She was so much more organized than I.

One time, in exasperation, she rebuked the Teacher himself for allowing me to spend so much time with him.

"My Lord, don't you care that I have to do all the work, while my sister just sits there without helping me?"

Would he send me away? Were his words meant only for men, like my brother, and not for me, too?

The Teacher held Martha's eyes for a moment, and then spoke her name, "Martha." He paused until he had her full attention. "Martha, you are concerned about many things, but Mary has chosen the best part, that which shall never be taken away from her."

I saw hurt flicker through my sister's eyes, but she didn't say anything; she only turned and walked back into the house. But after that she did join us more often in the garden.

As time went on, our family realized the importance of his message and the significance of the storyteller himself. He was more than a friend or a teacher. He truly was the Messiah. I followed him to the cross, my beloved friend. I saw him die. I saw him live again.

When he finally left us, I remembered he had told us—all of his friends—that he would send his Holy Spirit so he could always be as close to us in heaven as he was here on earth.

"If I go away, I will send you the Comforter, who will be with you. And I will come again," he said. I didn't have to give him up. It was as if he had never left. (John 14)

Note: So many women while having to function as a Martha, long in their hearts to be a Mary, even if only for a while. Mary is one of the beloved women of the Bible. A song, "Sitting at the Feet of Jesus," was written in her honor.

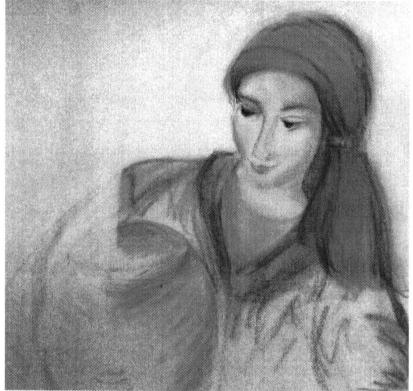

Martha, the Organizer

Martha, the Organizer

People called him the Prophet, this young man who traveled throughout our country preaching and healing. Our home provided him a harbor of peace and quiet, a reprieve from the badgering of the priests and lawyers who relentlessly followed him, a resting place where he could relax, pray, and meditate. We were family to him—my sister, Mary, my brother, Lazarus, and I.

He was always our welcome guest. He talked with us friend to friend, sharing his vision of God, pointing toward a future in God's kingdom, telling us that those who believed in him would have eternal life.

His every word captured Mary's attention—pensive, thoughtful Mary. She stopped everything and sat at his feet, listening, leaving me to oversee the cooking and have towels at hand to wash the visitors' feet if his friends came with him.

It annoyed me! But when I asked him to send her to help me, he reproved *me* instead of her. "Martha, Martha," he explained kindly, "you take care of so many things. Mary has chosen the better part, that which will last." I left her sitting at his feet, although grudgingly. Actually, after that I did try to take a little more time to listen—until urgent chores drew me away.

He was special to us all; this dynamic young man we believed was sent by God. Yet one event eclipsed everything. . . . I can't explain what happened. I only know it happened.

Our brother became ill. I bathed his fevered face and gave him goat's milk to sip, but he slowly faded and became weaker and weaker.

Tears streaming down her face, Mary cried, "If only he were here! He healed others, why not our brother?" Quickly we sent word to the Prophet that his friend was near death. We knew he'd come immediately. But he didn't. We waited and waited, watching our brother slowly slip into death.

"Why would the Prophet stay away?" we asked each other over and over, finding no answers.

Feeling totally betrayed, we buried Lazarus that day and grieved with the other mourners. On the fourth day, I saw Jesus slowly walking toward our home. My first thought was, *It's too late! He needn't come now!* Yet, even then, my heart leaped with anticipation when I saw him.

"If you had been here my brother would not have died," I said, my voice reflecting hurt and reproach. I'm not sure why, but I added, "I know that even now God will give you whatever you ask."

"Your brother will live again," the Prophet quietly said. It was almost as if he was preparing me for something, my eager heart knew not what.

"Yes, I know," I said. "I believe in the resurrection."

"I am the resurrection and the life. He who believes in me will live, even though he dies." He stopped and looked into my tear-blurred eyes. "Do you believe this, Martha?"

"Yes," I said. "I believe." Those few words set my heart at peace. All he had said before now came together for me.

"Let's go find Mary," he said, and we walked together in silence.

Mary welcomed him with her tears. "If only you'd been here, our brother wouldn't have died!" she accused, overcome by grief.

Somehow I knew something would happen, but I didn't know what. The crowd at the tomb hushed. Everyone felt the tension, the expectancy. The Prophet looked up into heaven and prayed to his Father, and then turned his eyes toward the tomb. Tears furrowed

down his dusty face. *He does care*, I thought. Others standing by said, "See how much he loved Lazarus."

"Lazarus, come forth!" he commanded. I held my breath. A rustling movement sounded from inside the tomb. We saw movement as the shadowy figure of Lazarus stood up, his grave wrappings unraveling around his feet. We could see all the traces of illness had vanished as he walked out, his face radiant, glowing with new life. He was whole! In awe the crowd stood back, electrified.

I can't explain it, but I saw it happen. We knew in our hearts that the Prophet truly was God. Sometimes I wish . . . sometimes I wonder, *What if I too had spent more time sitting at his feet, listening?* (John 11)

Note: Martha was the leader that kept her family together. Organized and efficient, she took care of others' needs. Perhaps the ideal life is a balance between being a Mary and a Martha—quiet time coupled with efficiency.

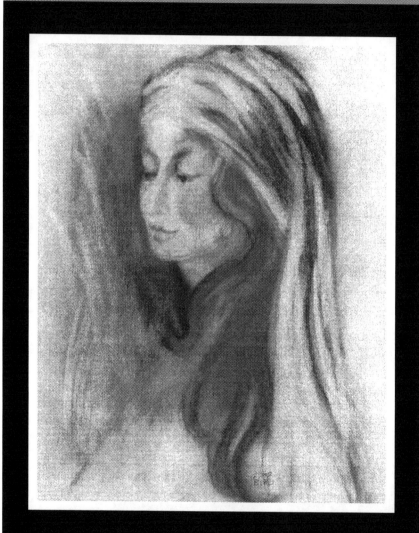

Pilate's Wife, the Silent Observer

Pilate's Wife, the Silent Observer

J agged edges of darkness clawed at my soul as I fitfully slept. Finally I dreamed, a terrifying dream. I saw a man crucified. I saw him die, a god-man suspended between earth and heaven. Then the deepest darkness I've ever felt blanketed me, and I awoke screaming.

The man in my dreams was the man I had seen in my husband's courtroom! A chill made its way down my back. Hastily I penned a message to my husband: "Have nothing to do with this just man." I got up, gave the message to a servant, put on a peasant's garb to disguise myself, and returned to the trial. I could not stay away.

That night the Jewish prophet, brought in by the priests, was to appear before my husband. I had heard about him and his miracles. Controversial, yes, but why would they want to kill a good man? I knew my husband would do all he could to save him, but would it be enough?

As I entered the room and slipped behind a column, I recognized him, the man in my dream. Never had I seen eyes like his—large, brown, soulful eyes that reflected exhaustion, sadness, and kindness. For a moment he caught my gaze, and his look burrowed into my very soul. I looked away as the trial began.

The early sunrise lit the horizon, the hills still dark. It was so near their sacred Passover that the Jews wouldn't enter the palace, so my husband questioned them from the balcony, "What charges do you bring against this man?"

"If he were not a criminal, we would not have handed him over to you," they replied.

"Take him yourselves and judge him by your own law," my husband flung back. I knew he didn't want to tangle with Jewish law.

"We have no right to execute anyone," they shouted.

My husband walked back into the palace and confronted the god-man. "Are you the king of the Jews?" I edged closer. I saw the tired expression of the man come alive. Among all the hardened faces that night, his alone was peaceful.

"Are you asking because you want to know?" the god-man countered.

"It is your people who are charging you. What have you done?"

"My kingdom is not of this world; my kingdom is of another place."

"You *are* a king then!" my husband exclaimed.

"You are right, for this reason I was born, and for this I came into the world, to testify to truth." It was a direct answer, and the man looked intently into my husband's face. There was silence for a moment.

"What is truth?" my husband questioned. I stopped breathing as I waited for the answer, but the clamoring crowd outside cut short the intense conversation, and my husband walked out to them again.

"I find no fault in this just man," he shouted above the crowd. "It is your custom to release one prisoner at Passover. Shall I release to you the king of the Jews?"

With mob fury they chanted, "Give us Barabbas! Give us Barabbas!" I gasped, *Why? Barabbas is a criminal!*

Then my husband ordered the prisoner to be flogged, hoping that would appease the crowd. I turned away. I couldn't bear the sight of the soldiers mistreating him.

During this time a soldier brought my message to my husband. His countenance blanched.

Once more he walked to the balcony to speak to the mob that swelled larger, becoming louder and angrier all the time.

"I find no fault in this man," my husband shouted. They only screamed, "Crucify him! Crucify him!"

I saw the panic and fear on my husband's face. "You take him and crucify him. I find no fault in him." My husband's voice was almost a scream.

The crowd insisted, "We have a law, and according to that law he must die. He claimed to be the Son of God!"

My heart leaped—my dream, yes, that was what my dream had said.

My husband walked back to the man and asked "Where do you come from?" The only sound was my beating heart. "Do you not realize I have the power to crucify you or set you free?"

"You would have no power if it were not given you," the god-man replied, and then he looked into my husband's agonized eyes and said quietly, almost sympathetically, "The one who gave me to you is guiltier than you."

Large sweat drops formed on my husband's face and rolled down his neck, even in the morning chill. He paced the floor while the crowd grew more restless, shouting, "If you let him go, you are no friend of Caesar's." Fear and anguish filled my heart. The crowd had struck at my husband's weakest spot. I knew my husband didn't have the fortitude to stand against that accusation.

Then, to my horror, I saw him take a basin and wash his hands, saying, "I am innocent of this man's blood."

I wanted to scream, "Don't do it! Don't do it!"

Neither man could save the other that night, though both tried. The god-man would not make my husband's decision, and my husband was too weak to make the right decision. As the soldiers led the god-man away, my tears that fell were not for him; they were for my husband. (Luke 23; John 18, 19)

Note: Christ could have altered the events that night. He could have turned away from this drama of death and life. Obedient to God's will, he would not stand in the way of what had to be done. Even though in Gethsemane he prayed, "Let this cup be taken from me," he would not change the events that led him to the cross. His mission and destiny was to die for the sins of the world, that humanity might be free to choose eternal life.

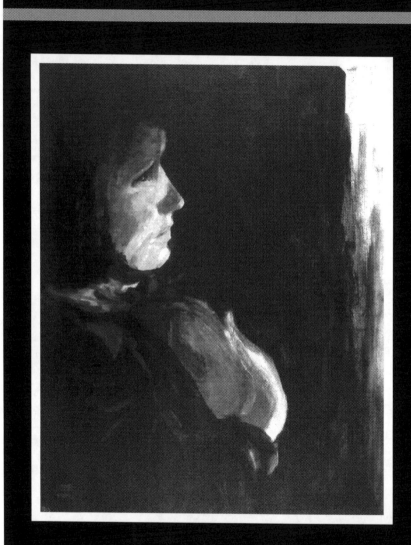

Mary, the Mother of Jesus

Mary, the Mother of Jesus

Bloodstains on my fingers. That's all I have left of my son, blood I caught dripping from the nail wounds in his feet.

My son—I stayed beneath the cross until he died. Then John took me to his own home. They wouldn't let me stay as they took his body down to prepare it for burial. So weak, I almost had to be carried. Now I just want to be alone—no tears. I have no tears left, I've shed them all. A cold, numb silence penetrates my empty heart. Darkness smothers my soul, as thick as the clouds that surrounded his cross. Agony strangles my mind, agony as deep as the nails that pierced his hands and feet.

Memories linger. Terror and grief grip my soul. I feel abandoned—alone. And I question. Oh, how I question! *My son, Why? Why? Why?*

But the angel said my baby was the Holy One of God . . . he would be great and be called the Son of the Most High . . . his kingdom would never end. Now they've killed him.

Every mother wondered if the little one she carried in her womb was the Messiah, but God chose me, a peasant girl, for that honor. The shepherds told of the angels filling the sky with light and song, telling them that the Savior, the Christ, the Messiah, had been born in Bethlehem. And they came and worshipped my baby son.

Oh, I remember the Wise Men that had followed his star. They too worshipped my baby and gave us gifts reserved for kings: gold,

frankincense, and myrrh—the most valuable of sacred oils. My baby, the long-awaited One? I was overwhelmed as I touched his tiny fingers and toes and felt his soft cooing against my breast. The Messiah? How could it be? Yet I believed and kept all these things in my heart.

I trained my son to be true to God. So kind, he cared for birds with broken wings and faithfully helped my husband, Joseph, in the carpenter shop. He even revered him as if he were his father. Now my tears are falling again.

I still remember our panic when we lost Jesus, just 12 years old. When we found him three days later, he was in the temple surrounded by priests. And he was asking profound questions of *them*. He noticed us then, and the look in his warm, brown eyes almost expressed a rebuke for our anxiety: "Don't you know I must be about my Father's business?"

It was I who taught him to love his heavenly Father. It was I who told him about his birth. Did I do wrong, encouraging him in his mission?

Oh, the miracles that followed him. At the wedding feast, as a special favor to me, he turned the water into wine, the best-tasting wine the guests had ever enjoyed. I've kept all these stories in my heart. He truly was the Messiah, the promised One—I thought. Now he is gone. All I have is his precious bloodstains on my fingers.

Blood . . . I wonder . . . he came to save his people from their sins; the angel told me that . . . at his baptism, John called him "the Lamb of God, who takes away the sin of the world" . . . I wonder . . . when we sin, we offer a lamb . . . a lamb has to die. Could it be that he, the Messiah, would have to die to save us? to bring us back to God? (Matt. 1:21-23; John 19:25-27; John 3:16)

Note: Jesus' mother, Mary, saw her son after the resurrection and is especially mentioned in Acts 1:11-14 as being with the disciples praying for the Holy Spirit after Jesus was taken to heaven from the Mount of Olives. "This same Jesus who has been taken from you into heaven, will come again" (verse 11).

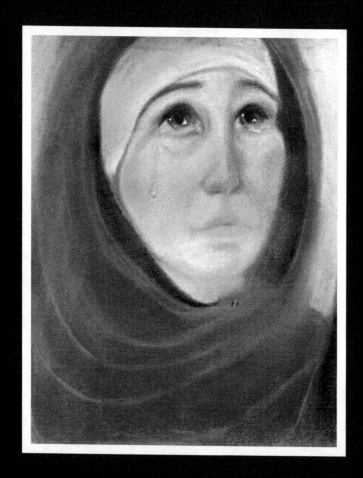

Mary, the Adoring One

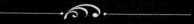

Mary, the Adoring One

The bread lay half-eaten on the rough table as I wrapped my shawl around me to ward off the early-morning chill. Tormented, I had sought sleep, but it had fled. Most of the night I and a few other women had prepared the burial spices, aloe and myrrh. But early that morning I had to go to his burial place first—to say one last goodbye. And I had to go alone.

It was the longest journey I had ever taken. I hardly noticed the stones cutting my feet as I ran, walked, paused—torn between wanting to turn back, to deny, and longing to be with him. Him in a cold, stone tomb, dead—my friend, my teacher, my life. I have never loved anyone more—my shelter, my comfort. He gave my life meaning. Now he was dead. Anguish pounded into my soul. Exhausted, I could barely breathe. I had to go on. I must linger in his presence one last time.

He was the Teacher sent from God, I thought. I will never forget the time my brother was ill—he raised my brother back to life! Some said he was the Messiah. I believed he was.

I remember the hours sitting at his feet, listening. His words, how can I explain them? Somehow listening to Him, I desired nothing else—just the peace he brought to my heart.

I could ask questions. He understood. When I got into trouble, he helped me back on my feet and never scolded me.

As I came to the tomb on the rocky hillside early that morning, clouds masking the rising sun hovered high in the sky, and my hands trembled as they touched the large boulder. It slanted to the side, not exactly in front of the tomb, but as if it had been rolled back. I looked

closer. What I saw gripped my heart. The tomb stood open, the scent of spice lingering in air that was fresh and new. I peered inside. It was empty.

A shock of surprise, followed by anger, raced through my body. Had not the soldiers done enough damage? They had taken his life from us! Now they had taken away his body, also.

Tears stung my eyes as I stumbled from the cave, almost running into the gardener sitting there.

"Sir," I demanded, "they've taken my Lord away! Tell me, where have they taken him?"

Then I heard my name, "Mary." Just one word, "Mary." My name, spoken in a tone I knew so well, one filled with love that restored my joy and energy. It was Jesus! I knelt at his feet to envelop him in my arms, but he held up his hand to stop me and said, "Wait, I haven't gone to my Father yet. Go tell Peter and the others that I am alive."

Peter, broken-hearted Peter, who felt crushed by guilt, the one who had betrayed and denied Jesus. I would give him the good news that his friend was alive and had specifically mentioned him by name. Oh, what that would mean to Peter.

My feet flew over the stony pathway that fresh, clear morning. As I ran, I felt his sweet presence with me and felt a wonderful peace.

"He's alive!" "He's alive!" "He's alive!" Those words pounded with my heart and kept time with my feet. And I wondered, *Will I have his sweet friendship still—now and forever?* Somehow, I knew I would. He is all he said he was. (John 20-18)

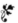

Note: Mary was the first to see the Savior alive after the resurrection, the first messenger to tell the others of a risen Christ. He revealed himself the first time as the long-awaited Messiah to the woman at the well. The first person to see and greet him after his resurrection was a woman. These stories have spoken to women through the ages. It is as if he is saying to womankind, you are accepted, forgiven, redeemed, and deeply loved.

The Author

E dna M. Gallington writes from her patio in Riverside, California. After a career in public relations and communication, she has put aside the deadlines and is enjoying writing creatively. During those years of writing news, newsletters, magazine articles, interviews, and coordinating workshops and retreats, she also found time to author several hundred pithy devotional articles and children's stories that have been published in magazines and books, with an international distribution.

She loves spending time with her Bible and the thrilling thoughts she gathers from God's Word. Many of these thoughts are written in her journal and later transformed into devotional articles. She treasures time hiking in the mountains, walking along the beach, sharing gourmet cooking with friends, and playing classical music and—for fun—soft jazz on her upright grand piano.

She lives with her husband, Wallace; a high-energy Belgian Malinois shepherd; a tiny Chiweenie; and an adoring cat, Mr. Snooks, who "writes" his own blog tattling to her friends about her escapades.

Edna and Wallace are certified leaders with the Association of Couples for Marriage Enrichment (ACME). She also holds a gold designation in Toastmasters, Inc. A devotional book, *People, Pets, and Plants*, of short personal stories, and a children's book, *Bobi Spots, a Misfit Kitten Finds a Home*, are in her future plans.

The Artist

A rtist Elizabeth Ann Bird Norton painted these pictures during the last 10 years of her life, during a long illness in which Linn, her adopted daughter, lovingly cared for her.

Born on March 15, 1922, in Long Beach, California, Elizabeth was only 14 when diagnosed with tuberculosis. The doctors told her parents, "Take her home and make her happy." She was in bed for seven years, most of that time in a sanitarium in Colorado.

Two Christian women came faithfully once a week to the sanitarium, stopping by each bed to share the gospel with the patients. Elizabeth hid in the bathroom or pretended to be asleep. She didn't want to hear about any of it! Eventually, however, she felt the pull of God's love on her heart and, at age 16, she gave her life to him.

She left the sanitarium at age 21, cured of tuberculosis, and returned home to Pomona, California, with her parents and brother. Five years later she married Wilbur Linn Norton, whom she had known since kindergarten. After 20 years of marriage, she found herself alone again with two children to care for. In frail health, she pulled closer to God in prayer and praise, longing to use her life and talent for him.

Drawing and painting had consoled her as a girl in the sanitarium, but now reading in the Scriptures of how God took care

of the lowly, the needy, and the sick—especially women who were in helpless, hopeless situations—brought the greatest comfort.

In her heart she wanted to use her talent to portray these women—capture the essence of each soul in eyes and facial expression—when they had been redeemed, cleansed, healed, and blessed.

During her artist years, she prayed for many weeks, reading the Scripture accounts over and over before beginning a portrait. She continued to pray throughout the day as she painted, according to her daughter, Linn. Many times she would come to a halt, not feeling satisfied with some part of the picture. She would then pray for guidance. Both she and her daughter knew when the picture was finished.

Most of these artistic renditions were created between the years 1973 and 1983. She finished her 24th picture before her death on April 25, 1983. Within the pages of this book, Elizabeth's dream has come true—to share her paintings with others.

Dear Reader,

Your life, like these women's lives, may be complicated, empty, or hedged in with incredible difficulties. Yet, as God provided special blessings for these women, he can do the same for you. May you, like them, look back on your life and rejoice in what he has done for you—the God who is "Watching from the Shadows" to guide and care for you.

Edna M. Gallington, author
www.ednagallington.com